Vive Le Color!

ROSES

COLORING BOOK

ABRAMS NOTERIE, NEW YORK

W9-APL-444

Check out the full line of *Vive Le Color!* coloring books and kits at **www.abramsnoterie.com**

ISBN: 978-1-4197-2523-4

Copyright © 2017 Hachette Livre (Marabout)

Illustrations © Shutterstock

Design: Else

Interior designs: aarrows 25, 35, 71, 109, Afishka 107, 117, 125, alicedaniel 15, 75, anfisa focusova 57, Danussa 31, Ekaterina Gerasimova 119, Ela Kwasniewski 13, Epine 135, fetrin 123, Huliiunska Yevheniia 113, Iryna Ometchak 99, J_bunina 101, JU-Whic 23, 27, 45, 49, 53, 67, 85, 111, kauaienkaua uolha 129, Keith Voronina 39, kotkoa 19, 37, Kynata 47, lolya1988 115, Ludmila Marchenko 5, 33, Martenes 103, More Images 65, 97, muu 141, Naddya 73, 81, 89, nata_danilenko 105, Nataleana 87, Nygraphic 137, oksanka0007 127, 131, 133, Olga Korneeva 93, Pim 51, Polina Katritch 143, Ran Sinee 121, Regina Jershoua 11, Rita Ko 9, ruulada 69, sntpzh 61, Tashsat 3, 17, 29, 41, 43, 63, 83, 139, uector graphics 79, ueron_ice 55, Victor Z 59, xenia_ok 95, Yuliya Koldouska 21

English translation copyright © 2017 Abrams Noterie

Printed and bound in China

10 9 8 7 6 5 4 3 2 1

Abrams Noterie products are available at special discounts when purchased in quantity for premiums and promotions as well as fundraising or educational use. Special editions can also be created to specification. For details, contact specialsales@abramsbooks.com or the address below.

ABRAMS The Art of Books

115 West 18th Street
New York, NY 10011
www.abramsbooks.com

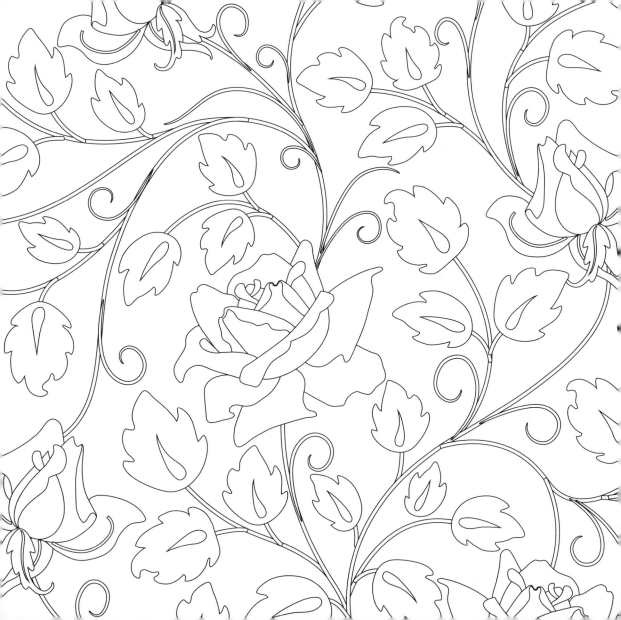

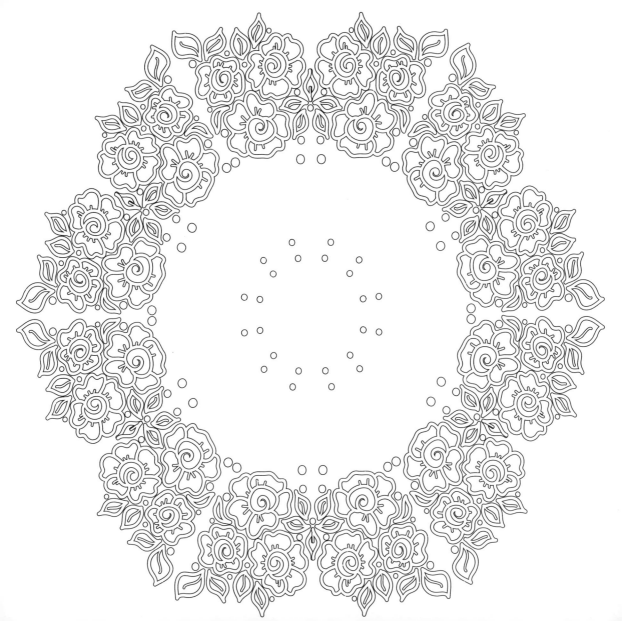

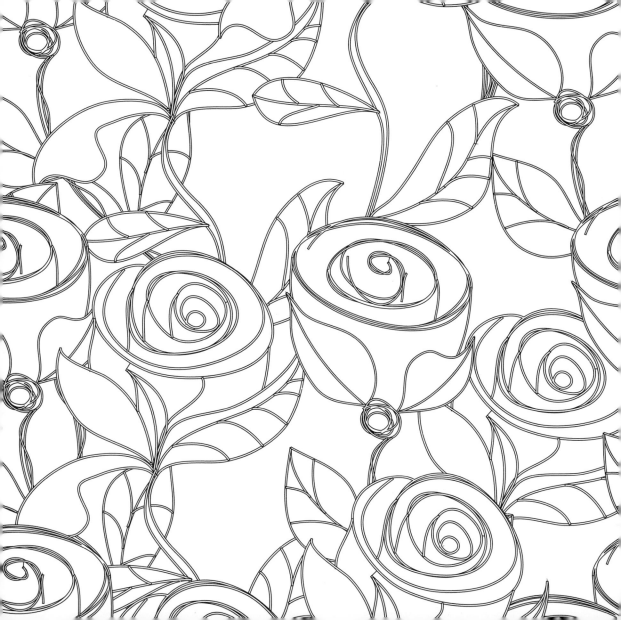

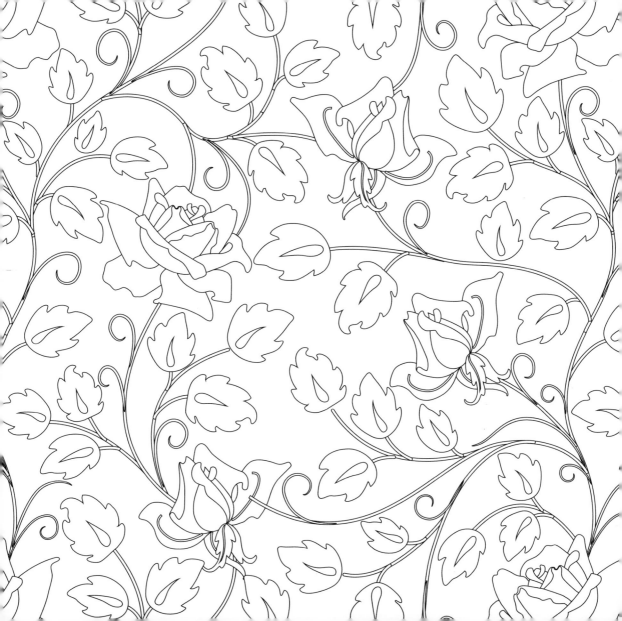

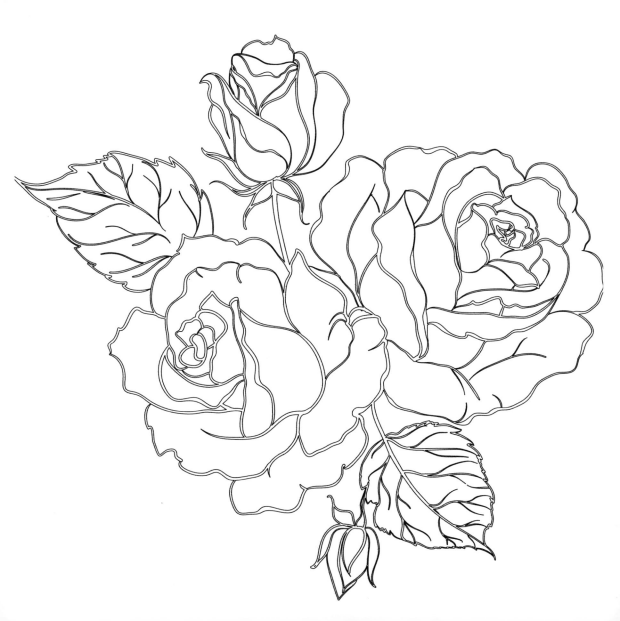

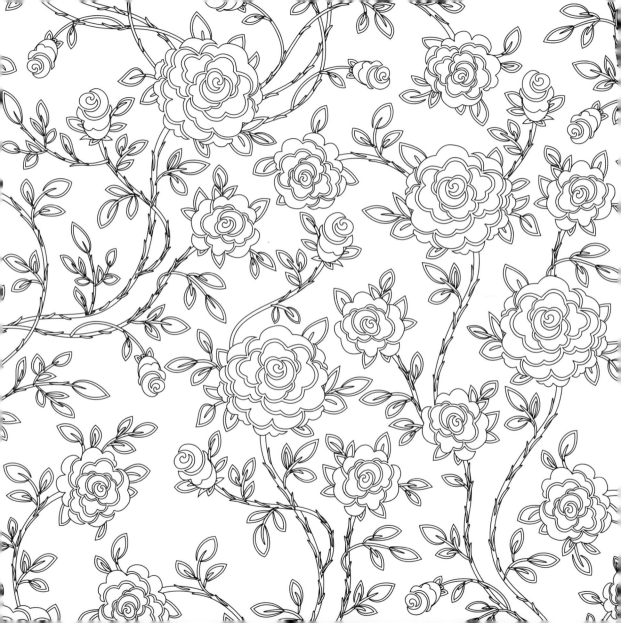

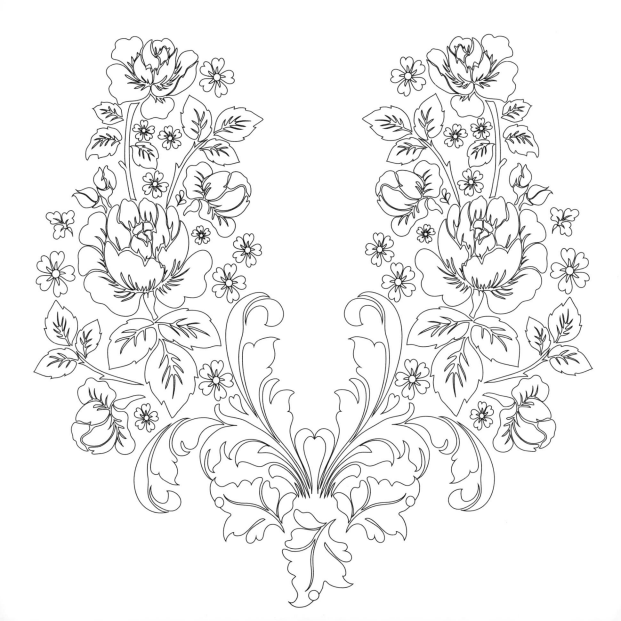

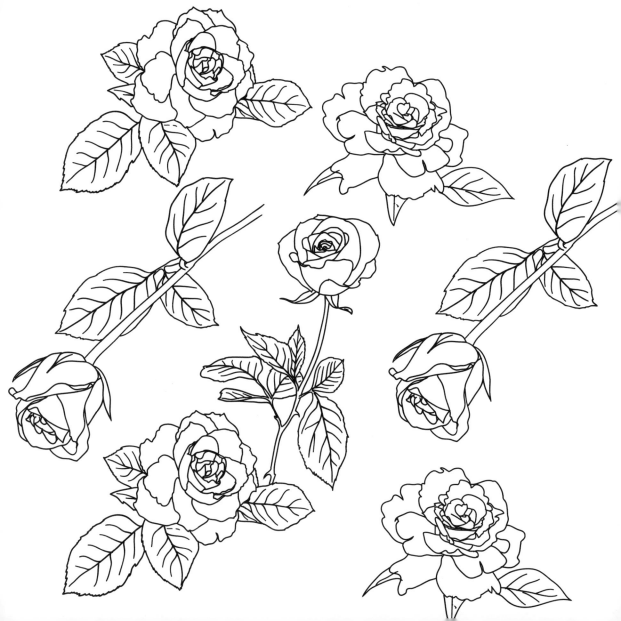

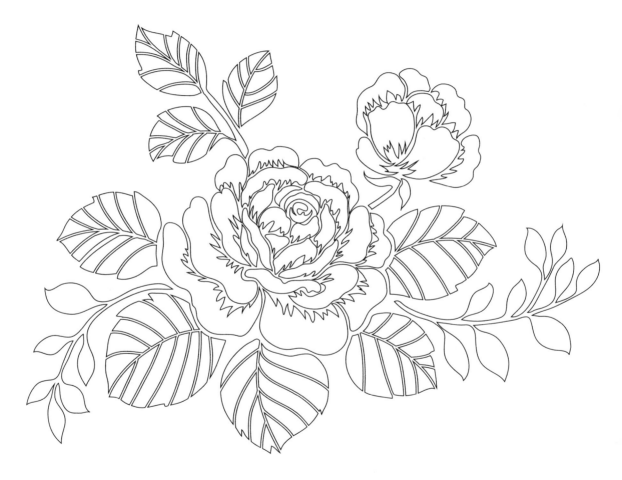

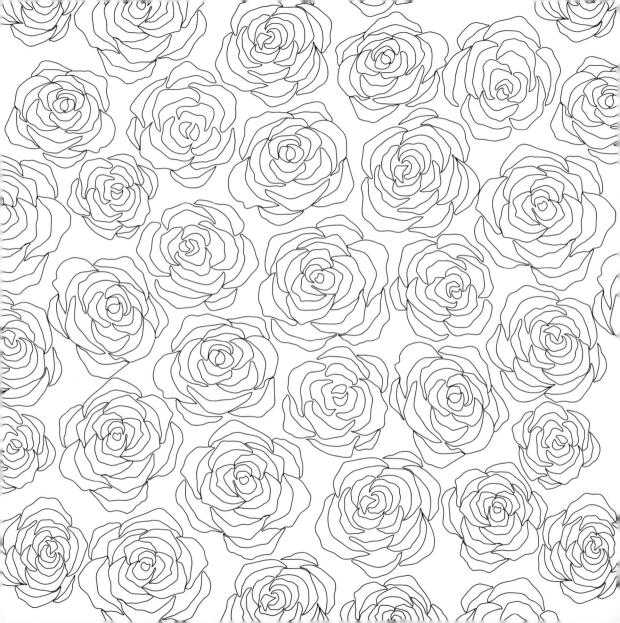

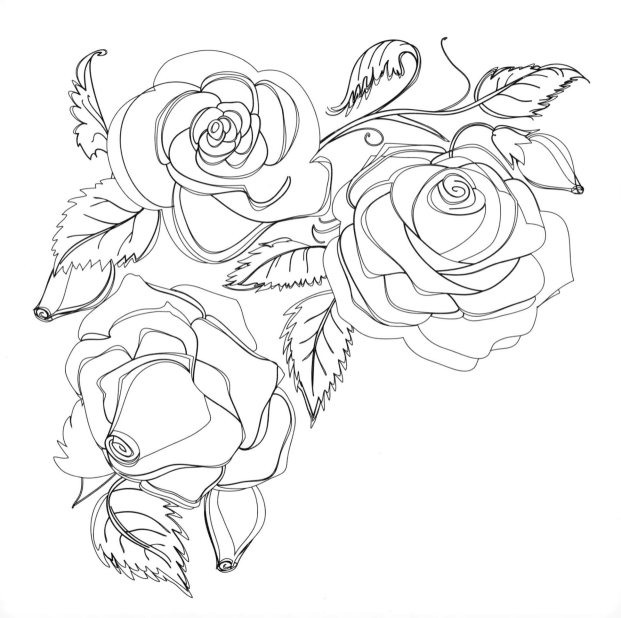

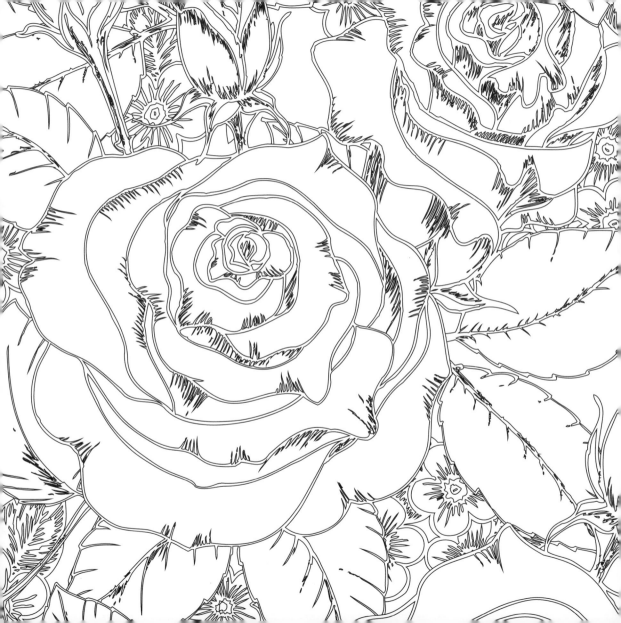

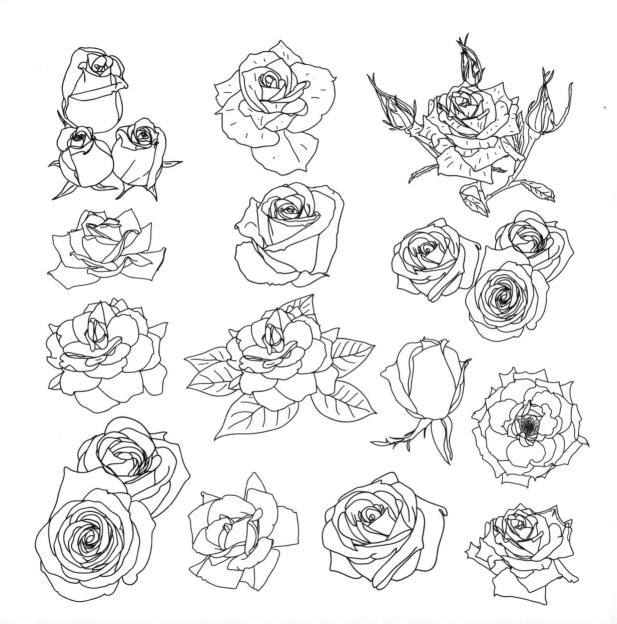

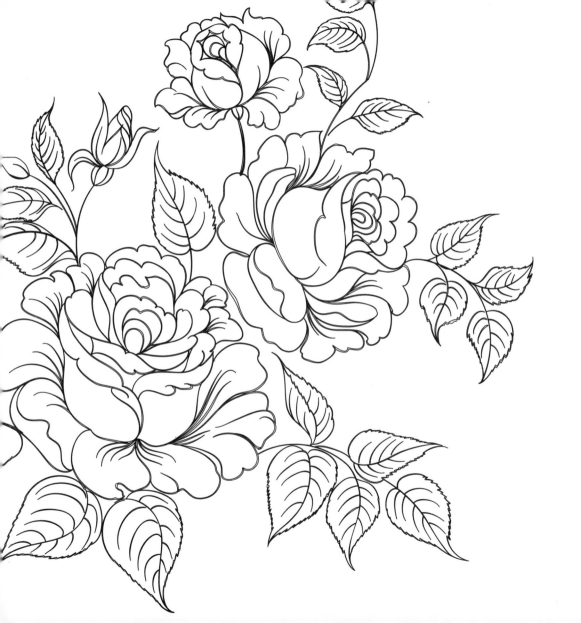

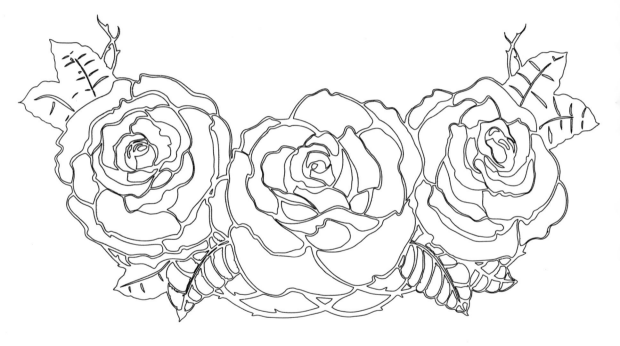

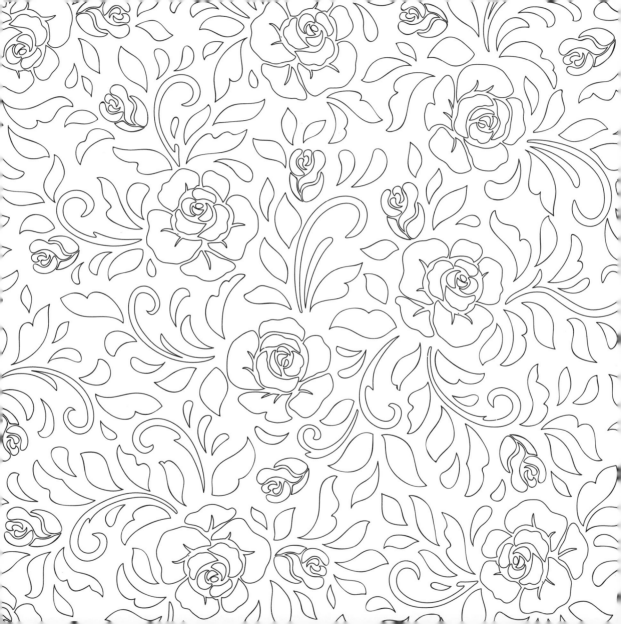

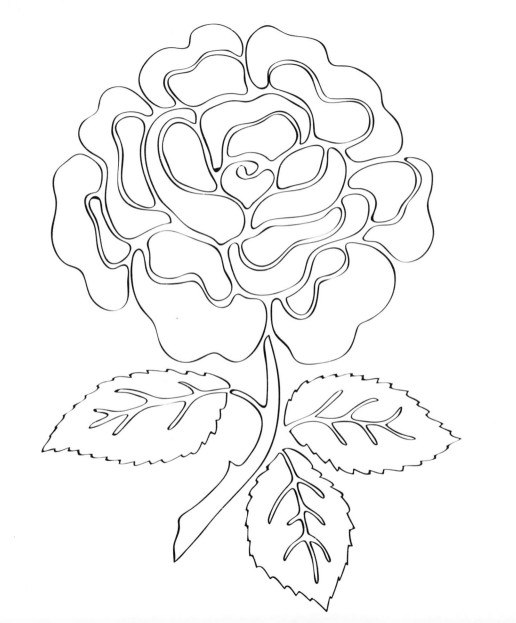

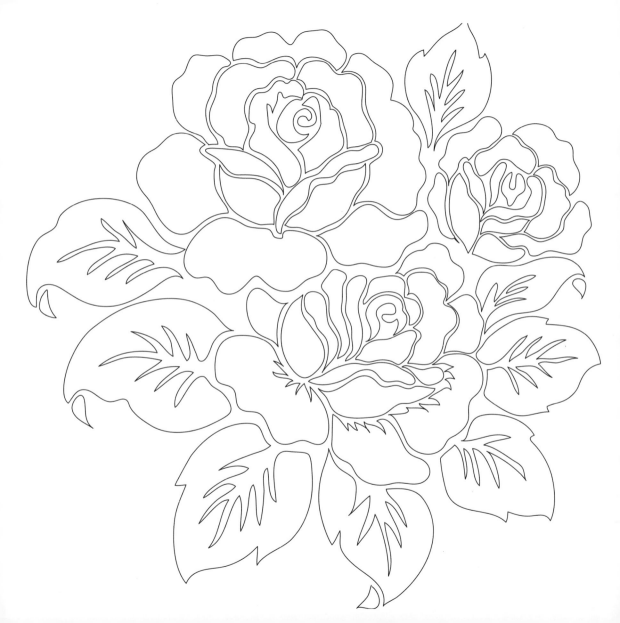

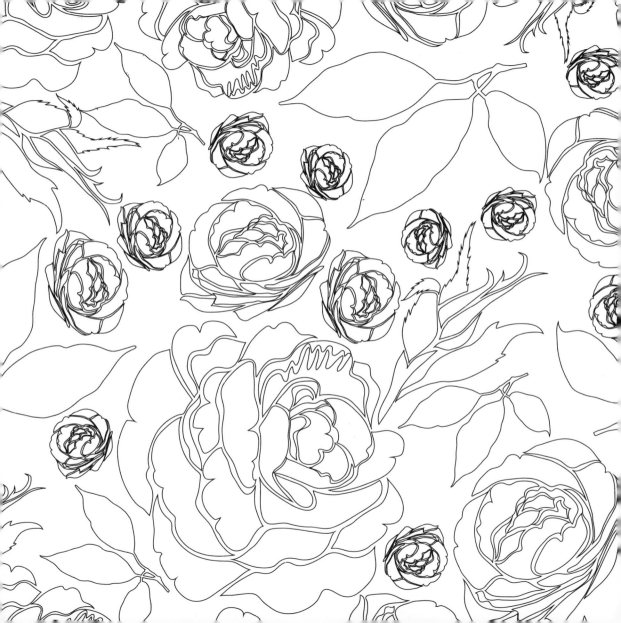

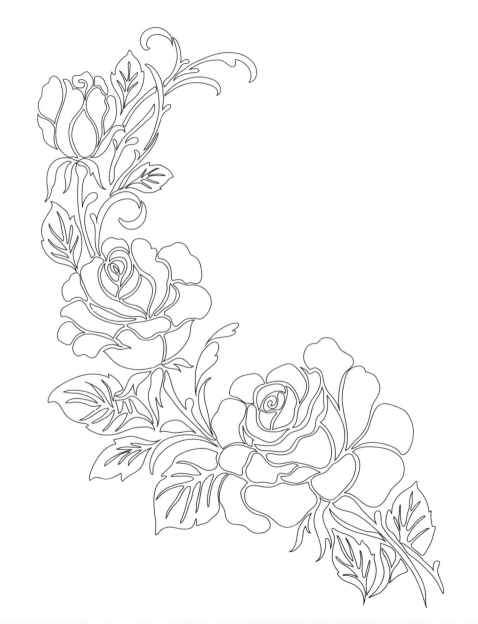

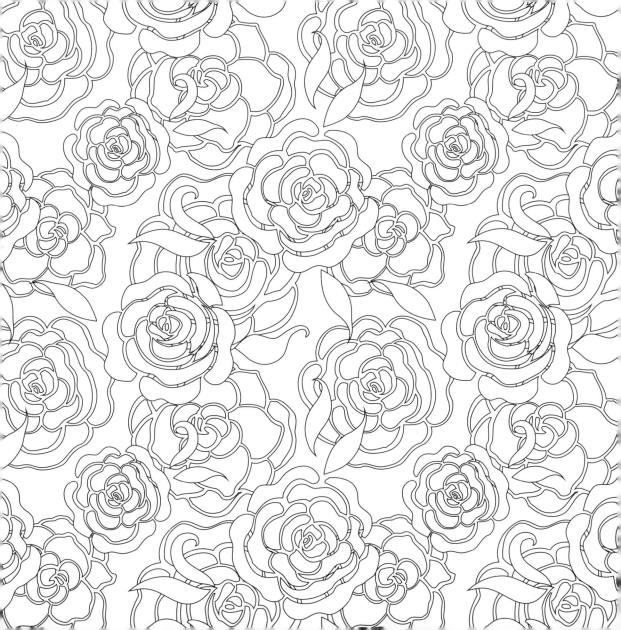

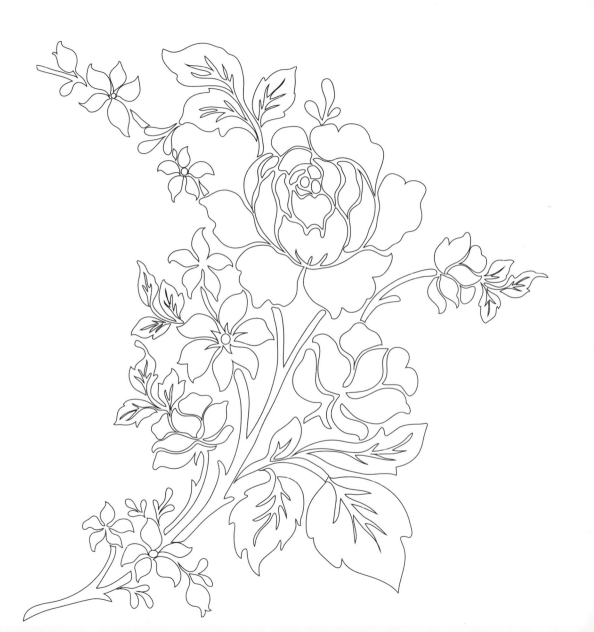

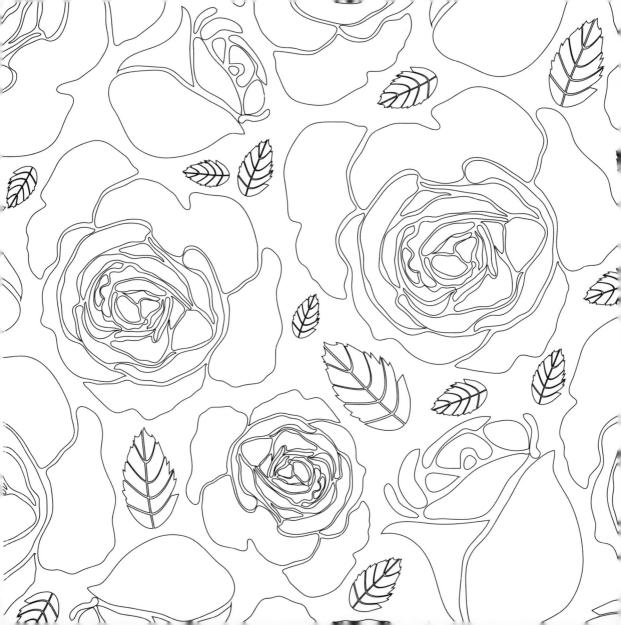

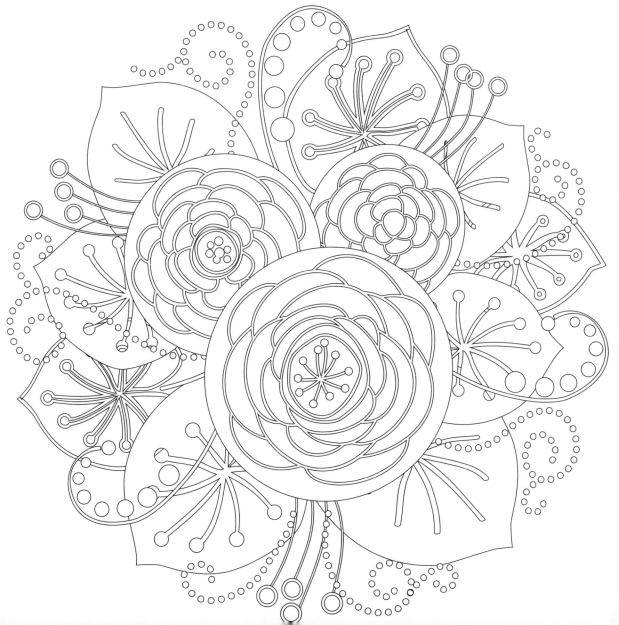

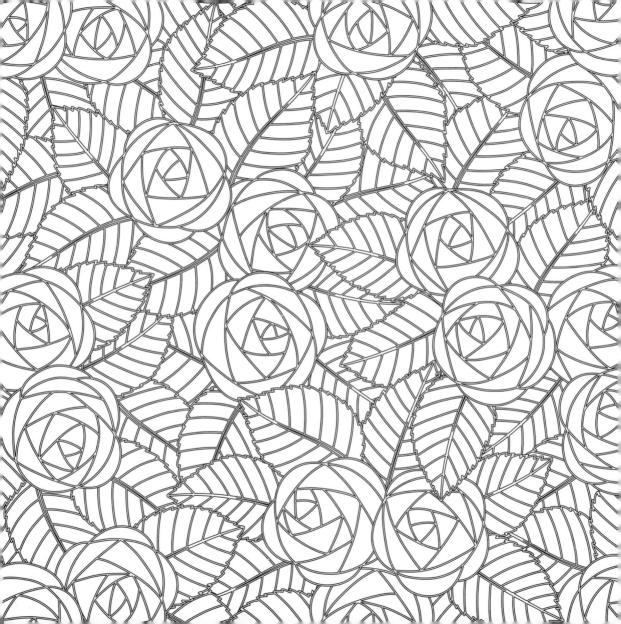

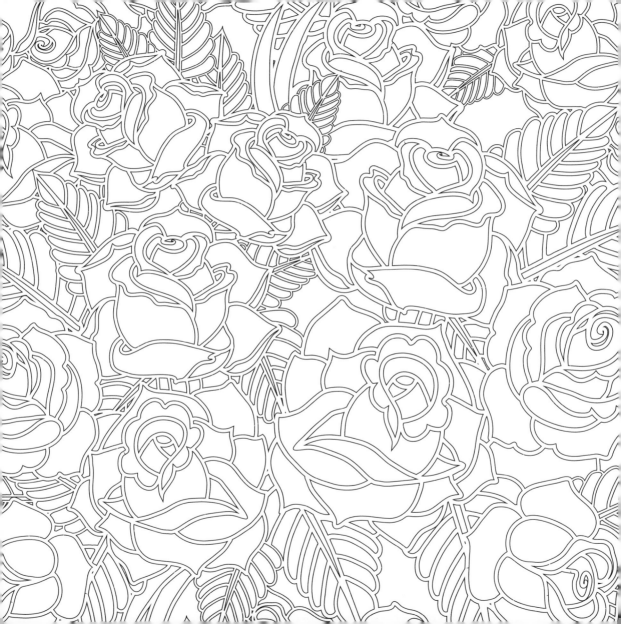

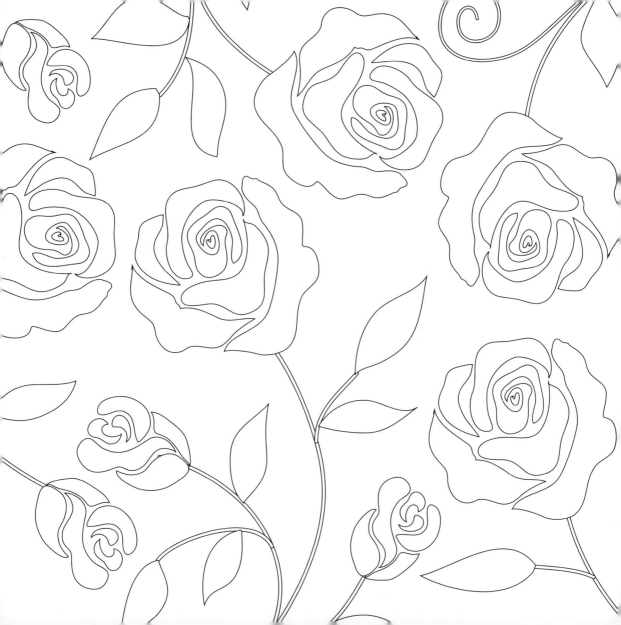

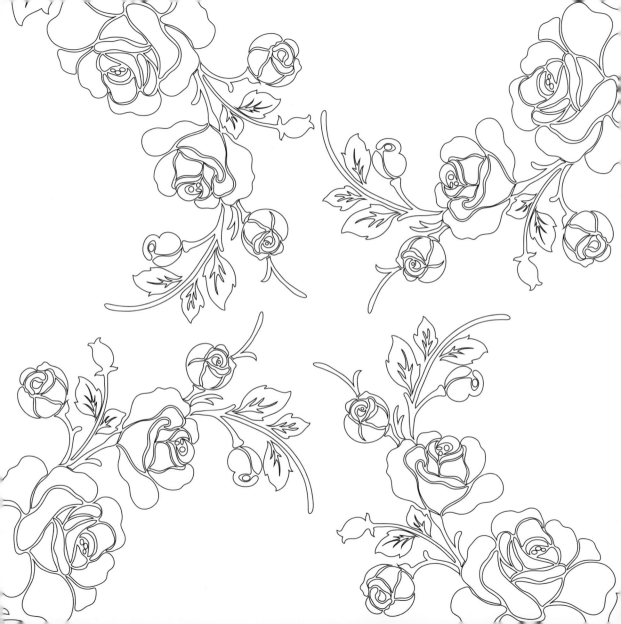

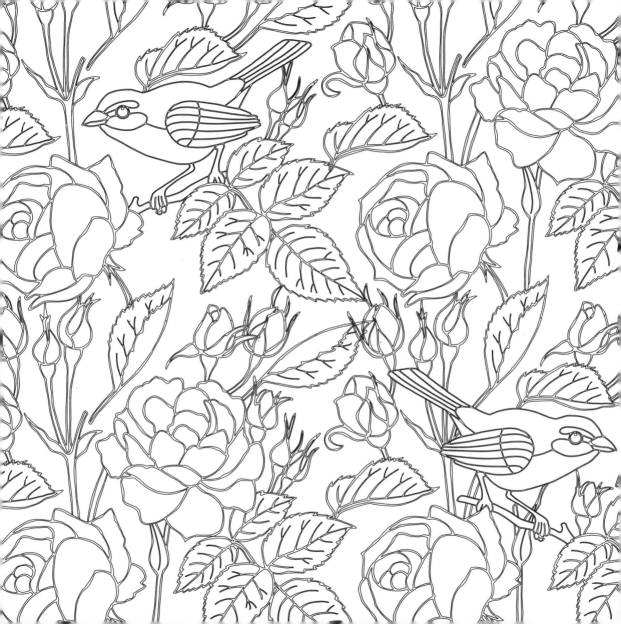

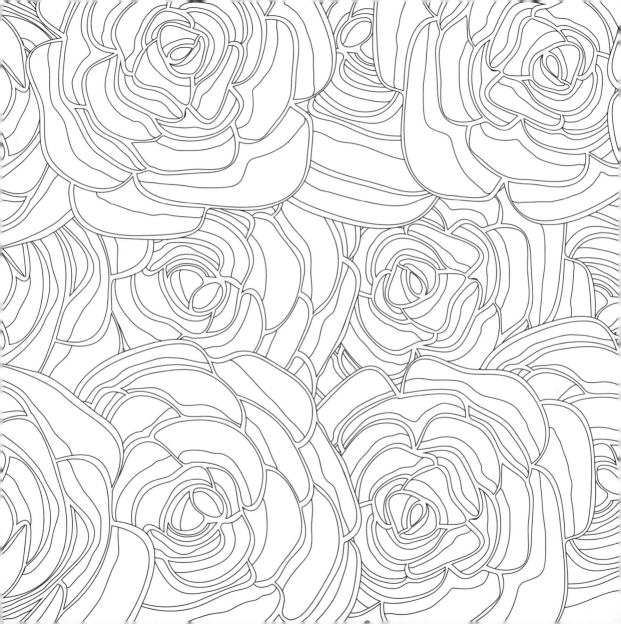

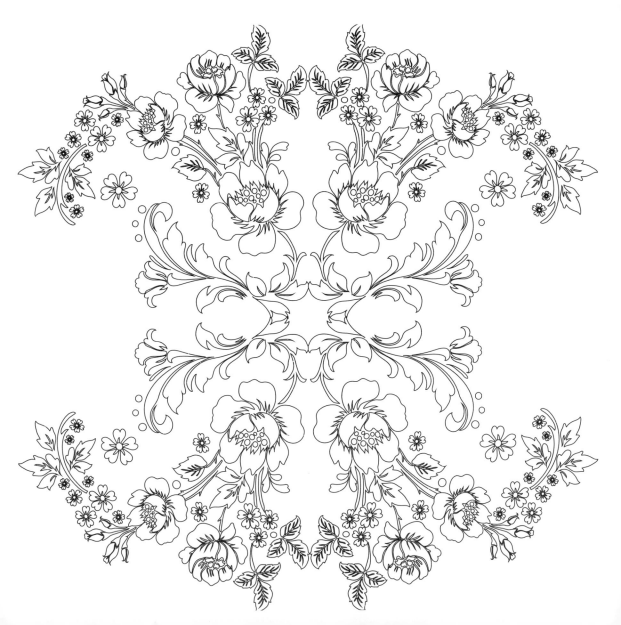

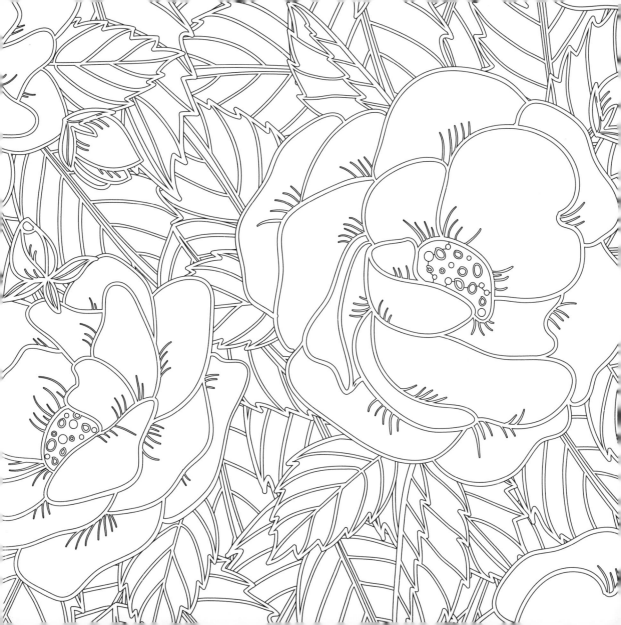

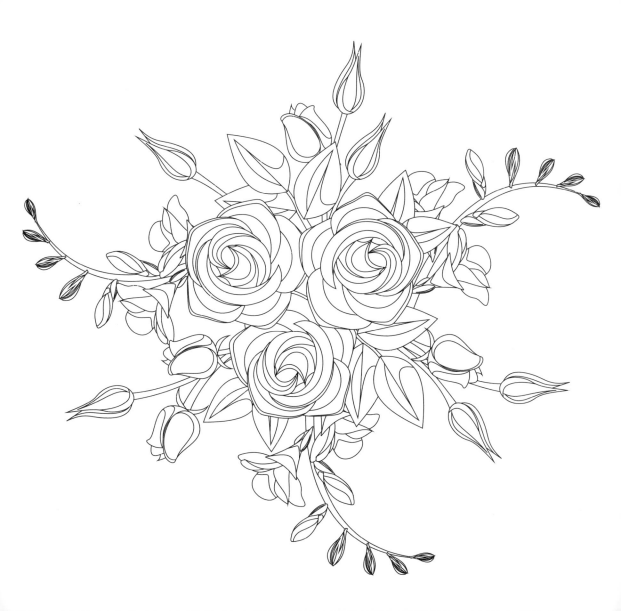

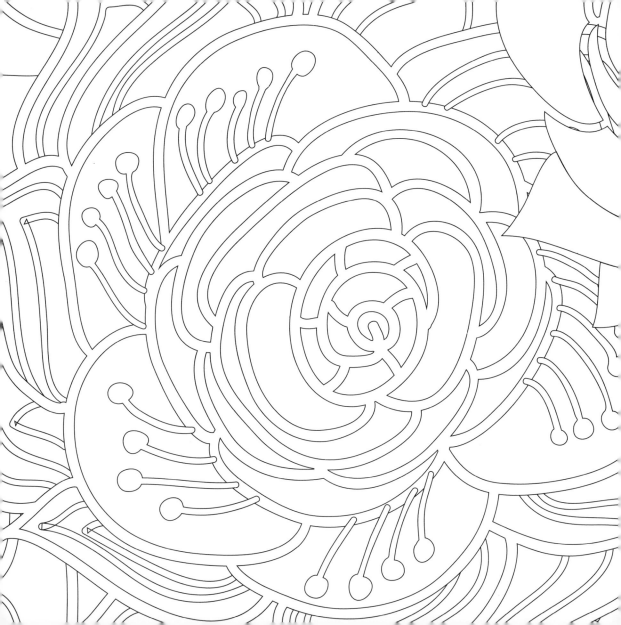

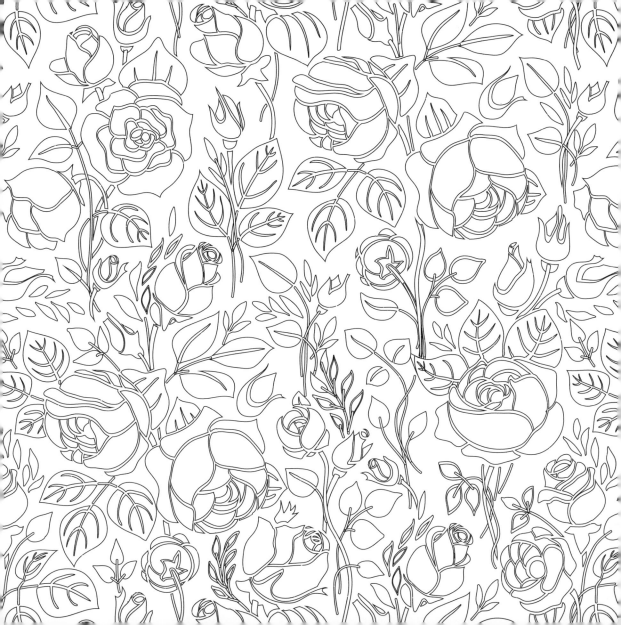

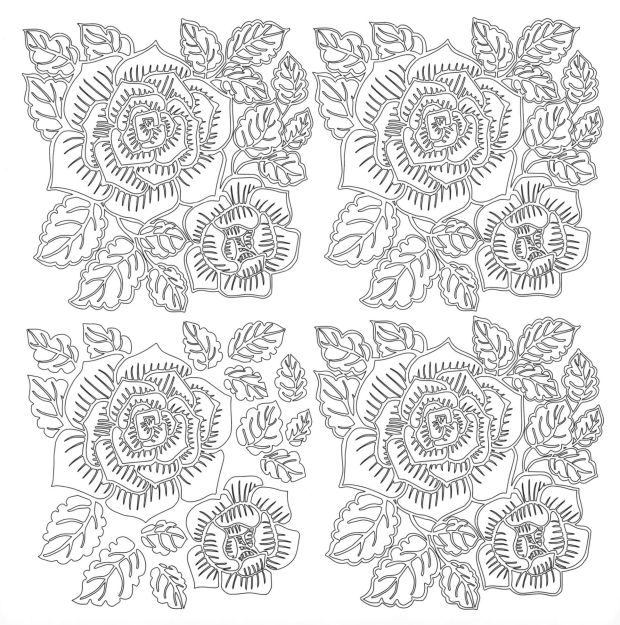

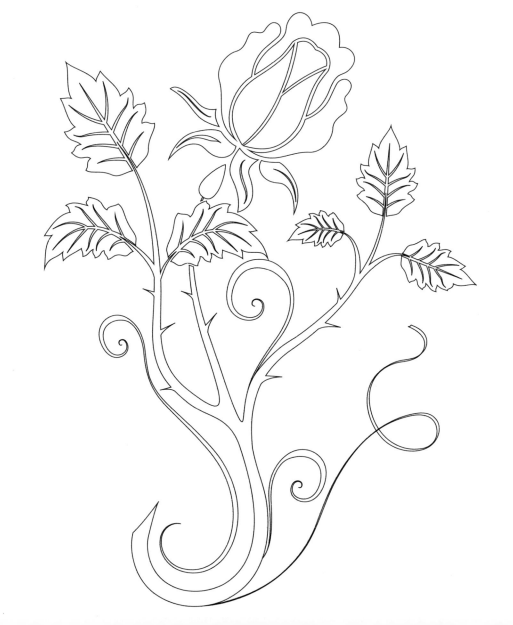

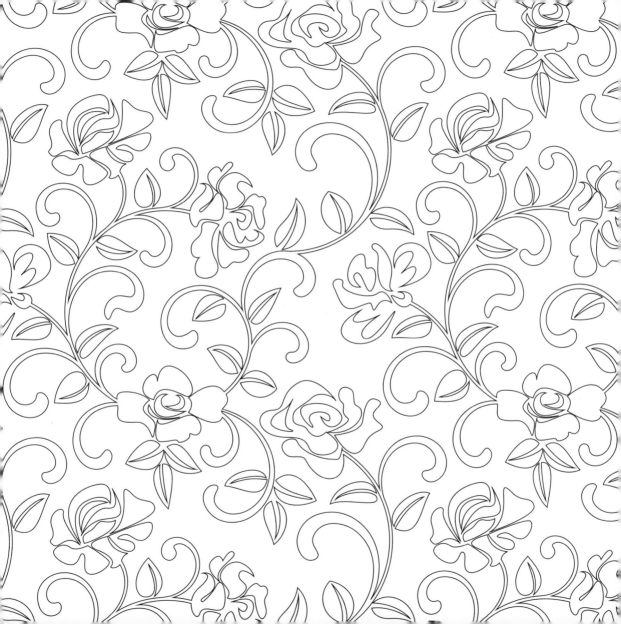

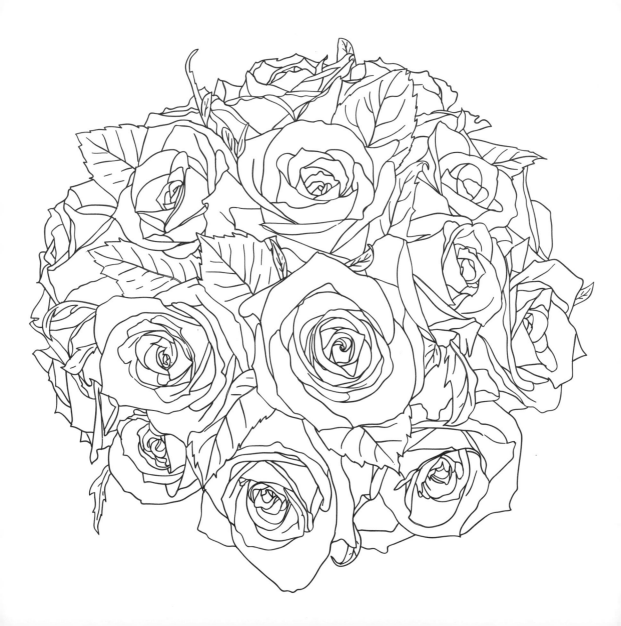

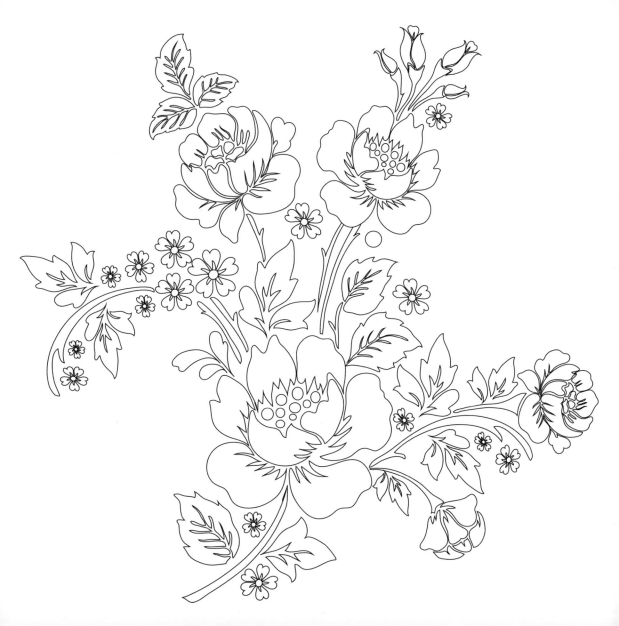

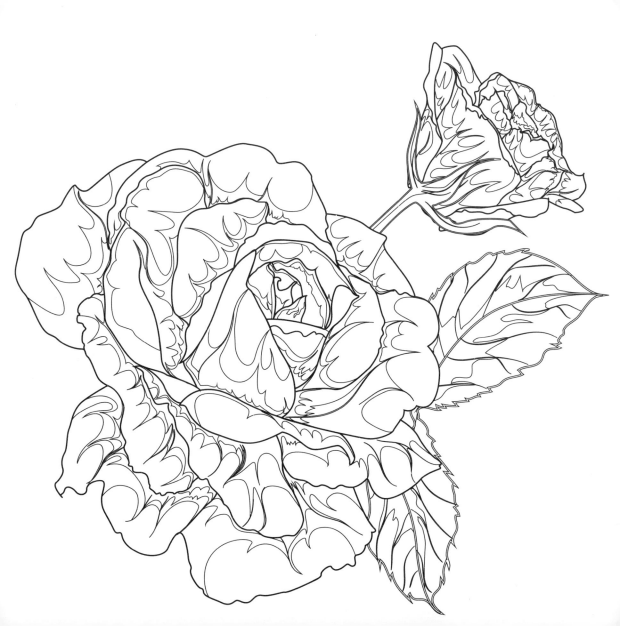

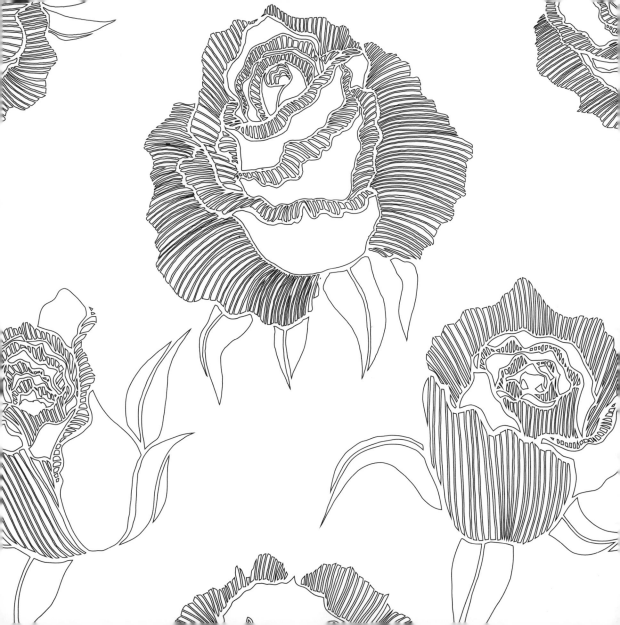

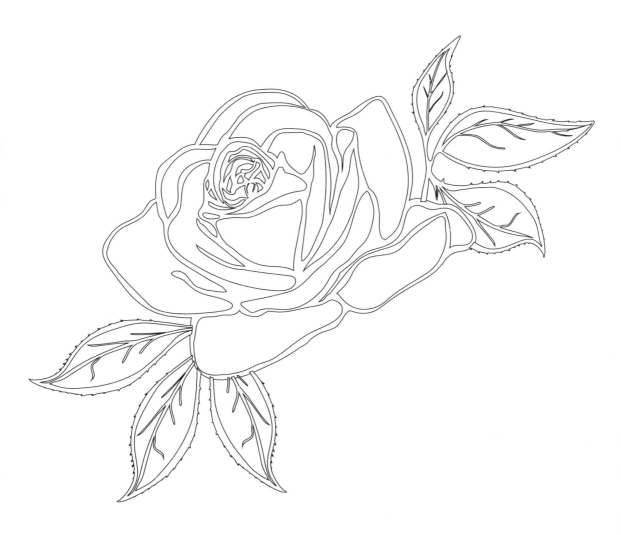

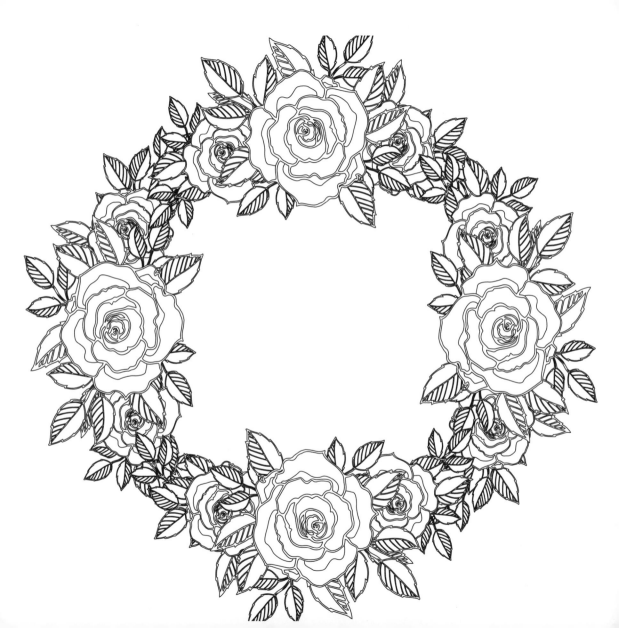

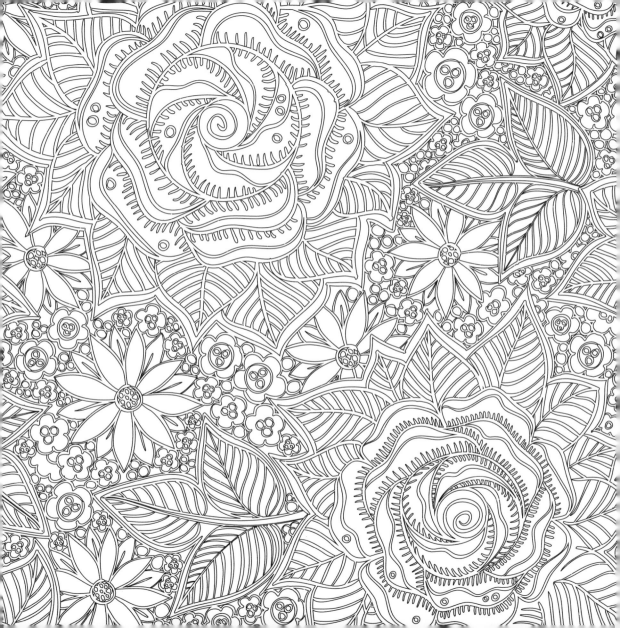

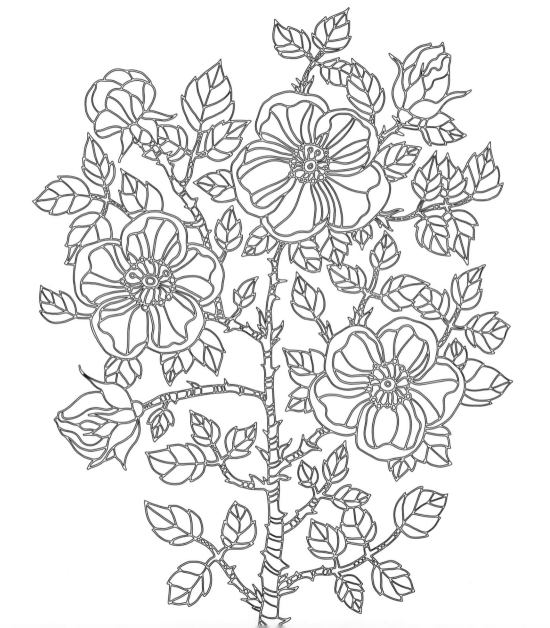

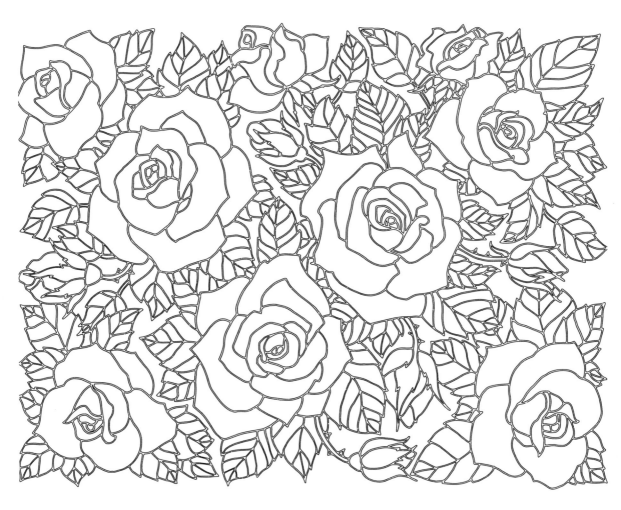

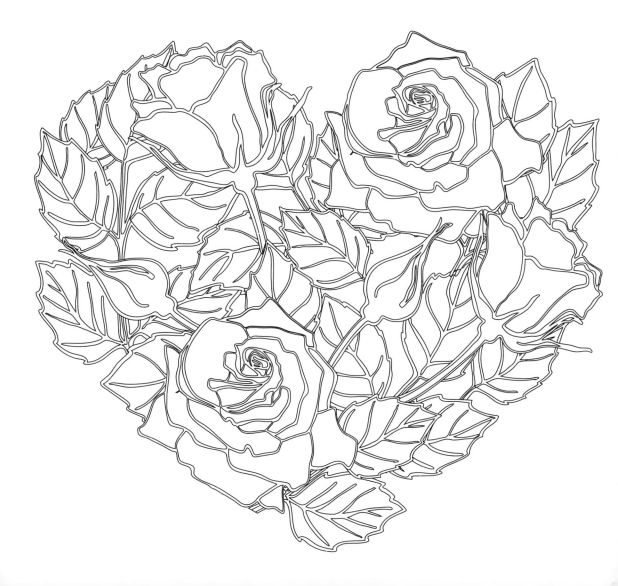

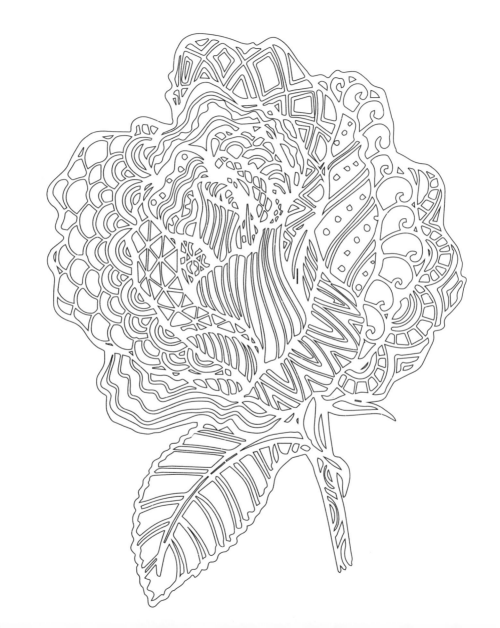

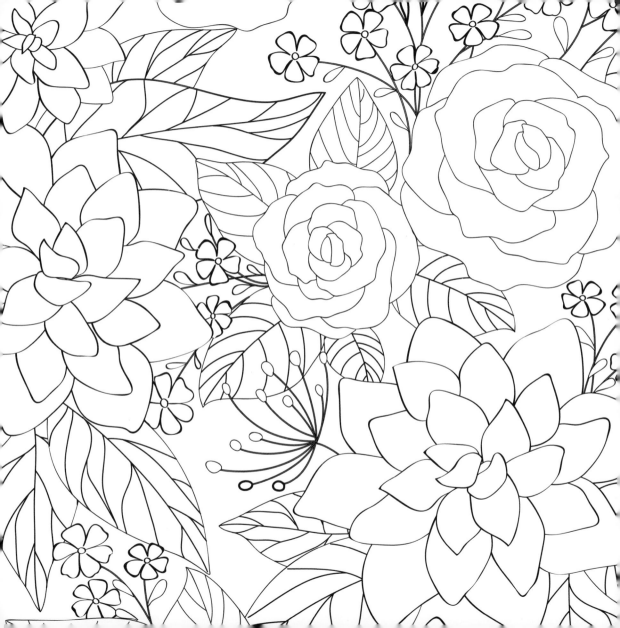